Moonstone Press

Project Editor: Stephanie Maze
Art Director: Alexandra Littlehales
Senior Editor: Rebecca Barns

PHOTOGRAPHY: Front cover: © 2001 Anup Shah/DRK Photo;
Back cover: © 2001 Norbert Rosing/National Geographic Image Collection;
in order, beginning with title page: © 2001 Frans Lanting/Minden Pictures;
© 2001 John Cancalosi; © 2001 Anup Shah/DRK Photo; © 2001 Joel Sartore/National
Geographic Image Collection; © 2001 Michael Nichols/National Geographic Image Collection;
© 2001 Frans Lanting/Minden Pictures; © 2001 Jonathan Blair/National Geographic Image
Collection; © 2001 Norbert Rosing/National Geographic Image Collection.
© 2001 John Cancalosi/DRK Photo; © 2001 Jim Brandenburg/Minden Pictures;
© 2001 Michael Fogden/DRK Photo; © 2001 Flip Niklin/Minden Pictures;
© 2001 Mitsuaki Iwago/Minden Pictures; © 2001 Anup Shah/DRK Photo;
© 2001 Norbert Rosing/National Geographic Image Collection.

ISBN 0-9707768-0-2
Library of Congress Cataloging-in-Publication Data
Tender moments in the wild : animals and their babies.
p. cm.
1. Animals—Infancy—Juvenile literature. 2. Parental behavior in animals—Juvenile Literature.
[1. Animals—Infancy. 2. Parental behavior in animals.]
QL763.T36 2001
591.56'3--dc21 2001030020

First edition
10 9 8 7 6 5 4 3 2 1

Printed in Hong Kong through Asia Pacific Offset

Tender Moments

In the Wild

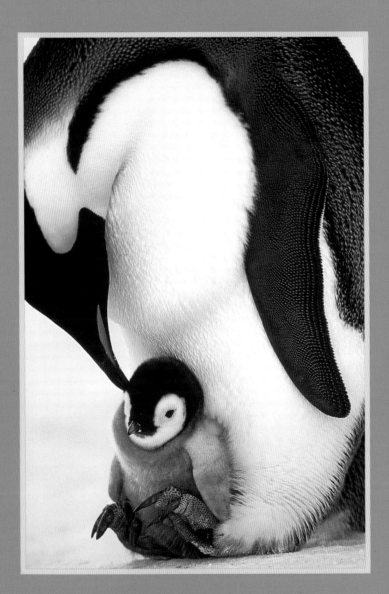

Animals and Their Babies

All around the world,
animals love their babies.

A **swan** makes sure
her baby is comfortable.

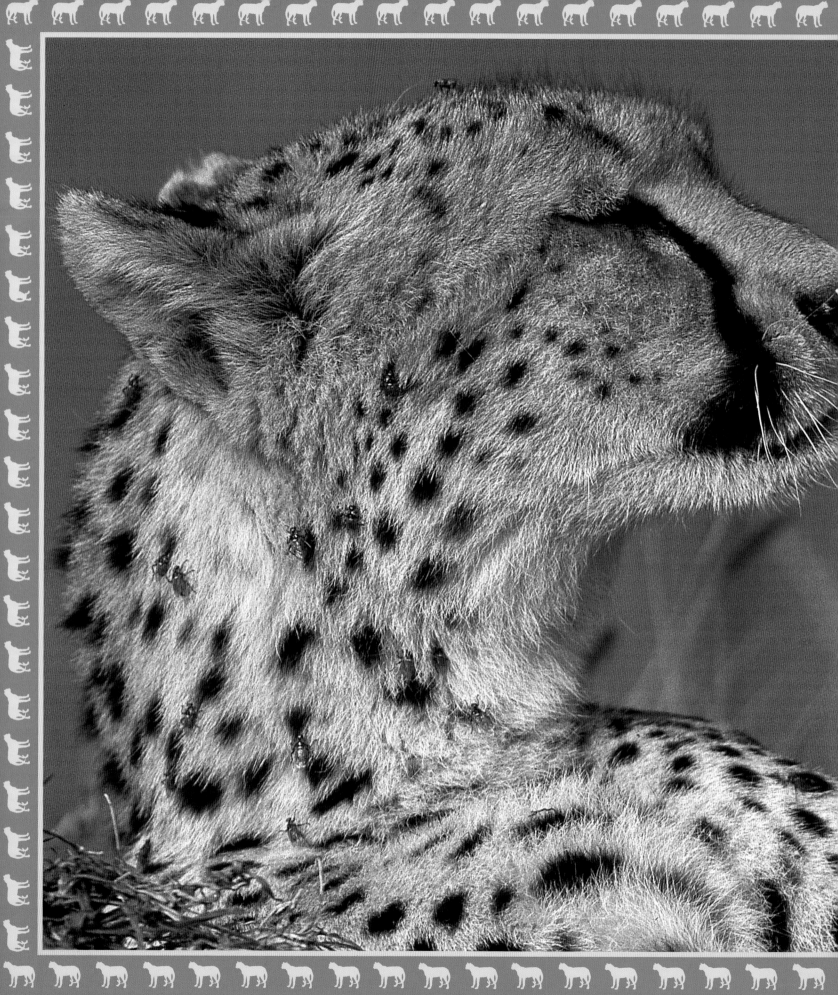

A **cheetah** nuzzles her baby to say "hello."

A **seal** cuddles with her baby on the beach.

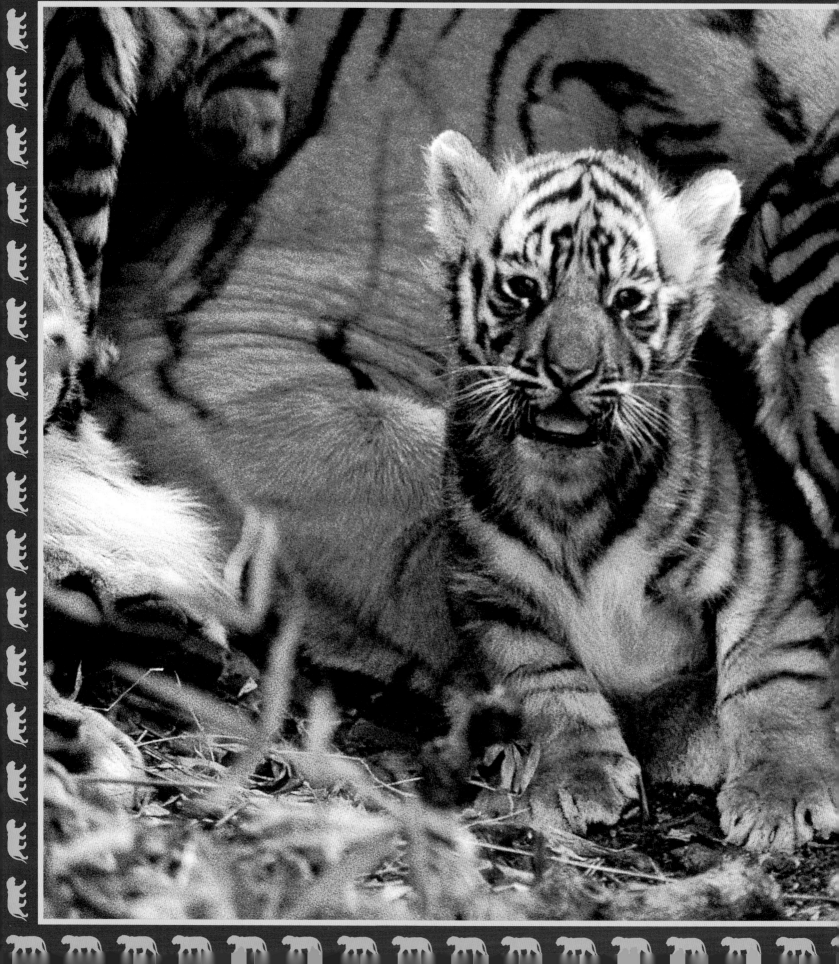

A **tiger**
washes her baby
with her tongue.

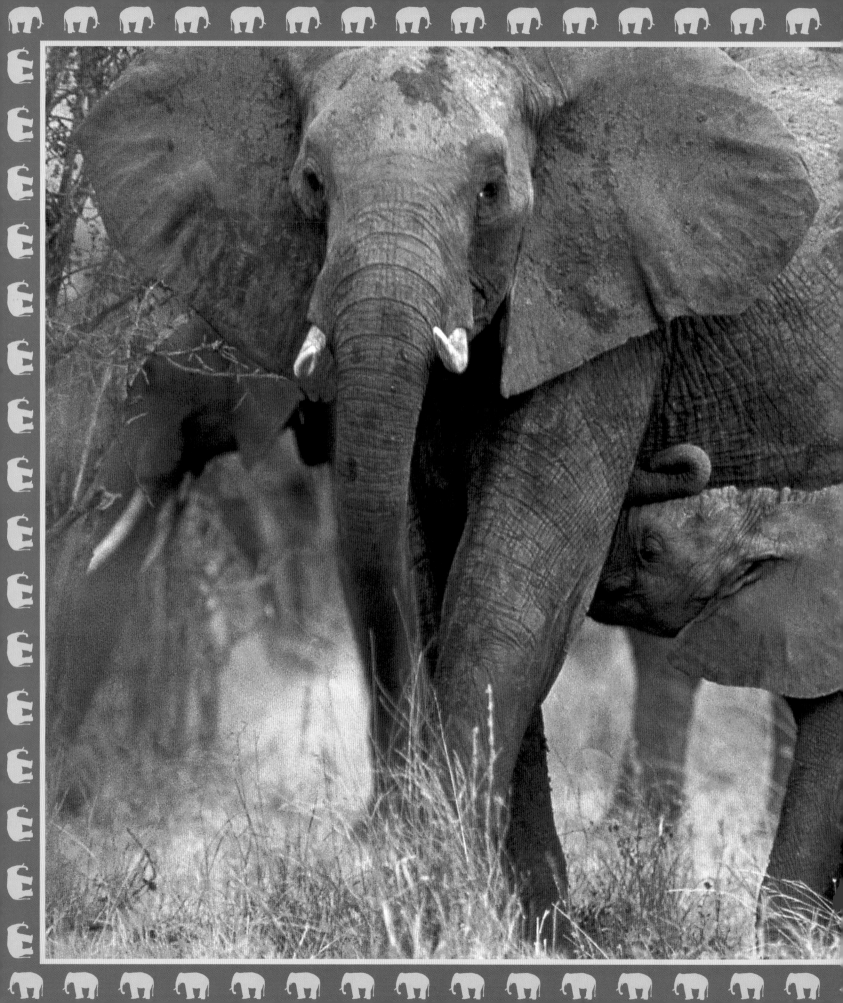

An **elephant** nurses her baby as family members stand guard.

A **crocodile** carries her babies carefully in her powerful jaws.

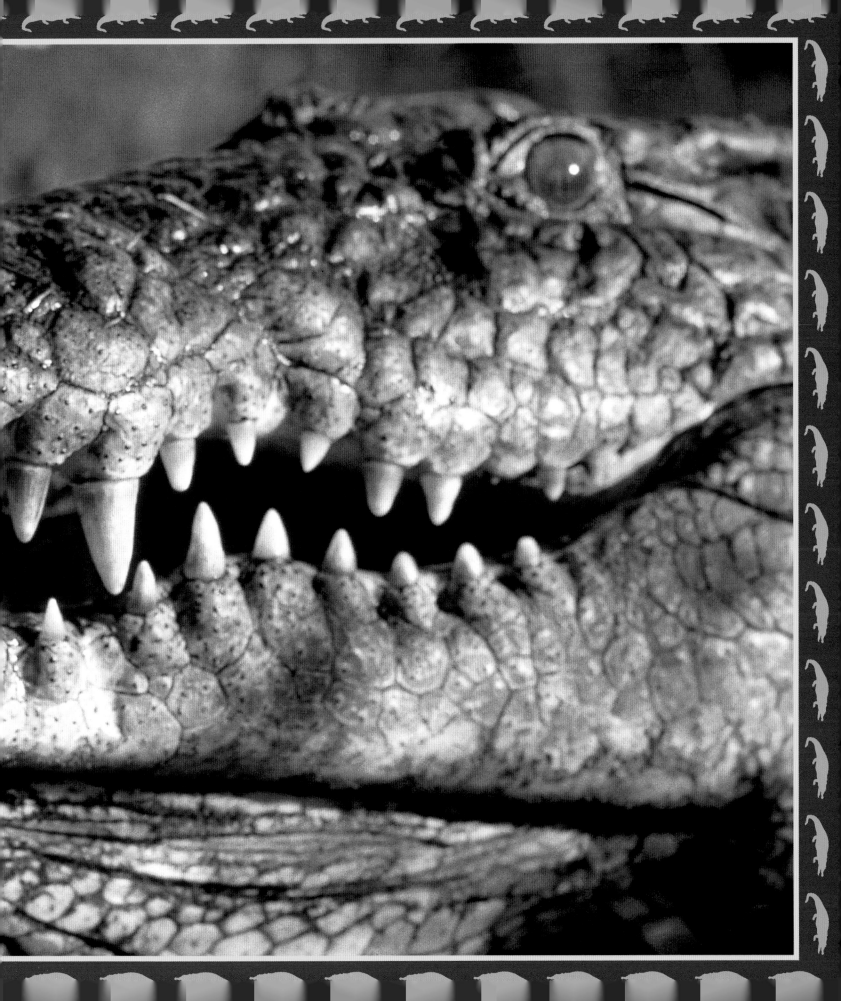

An **orangutan** holds her baby close to her.

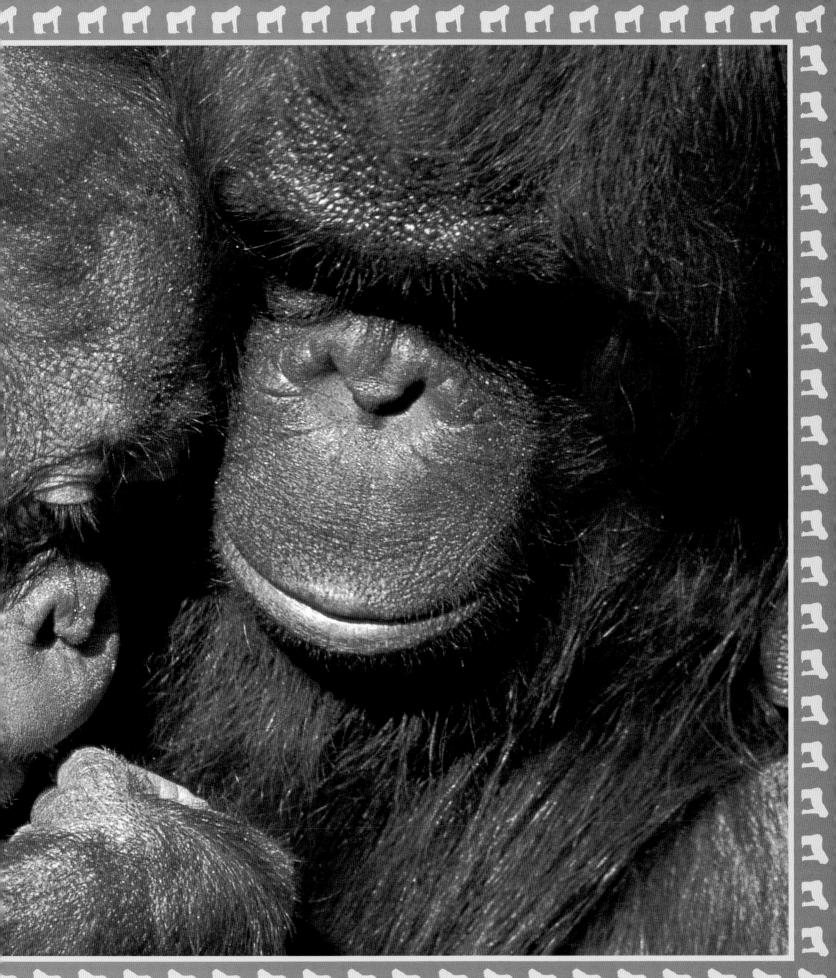

A **scorpion**
gives her babies
a piggyback ride.

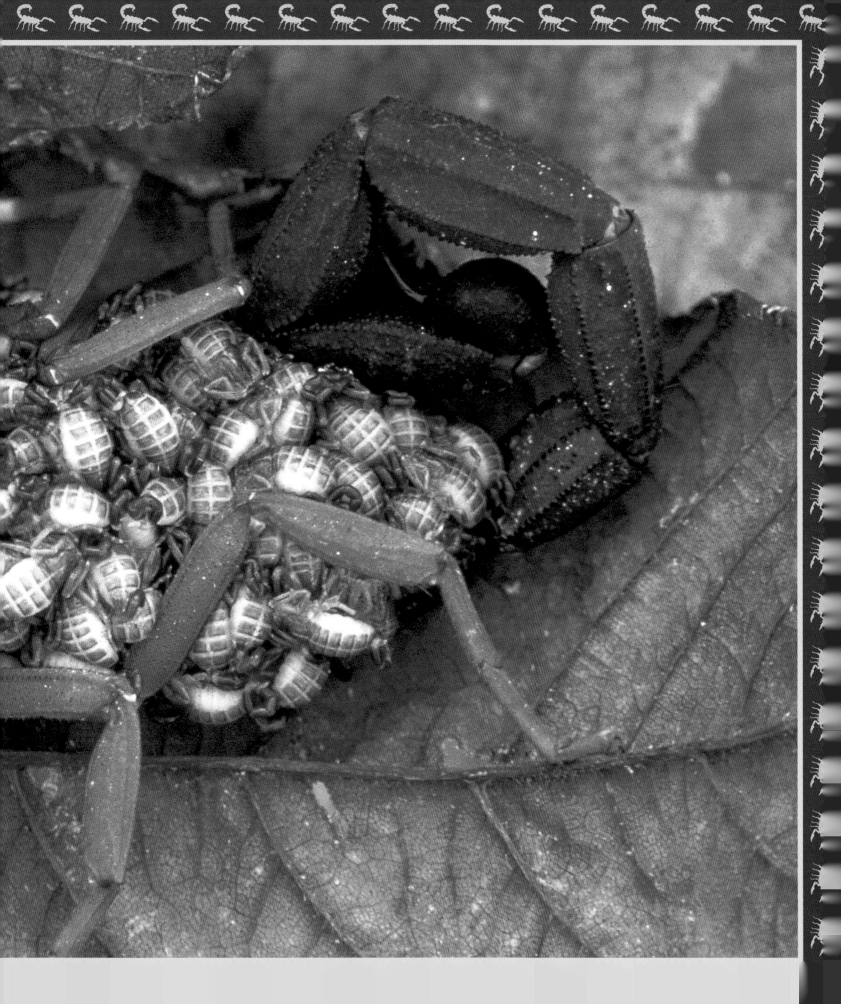

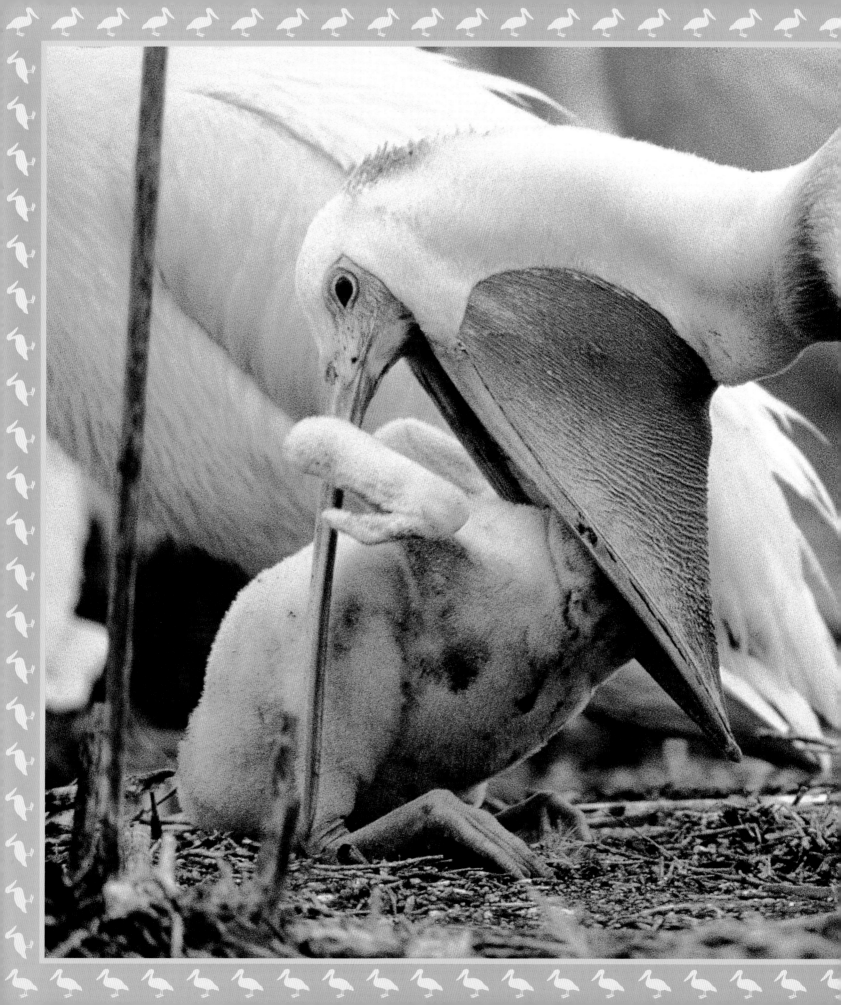

A **pelican** feeds her hungry baby some fish.

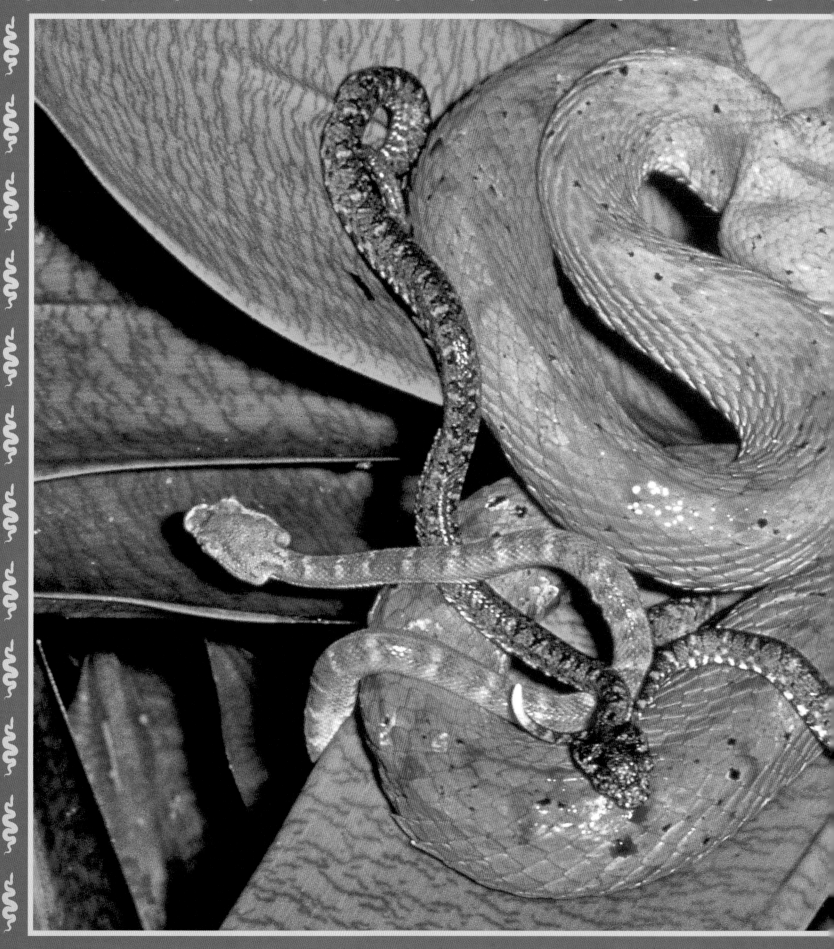

A **snake** watches her babies so they don't wander off.

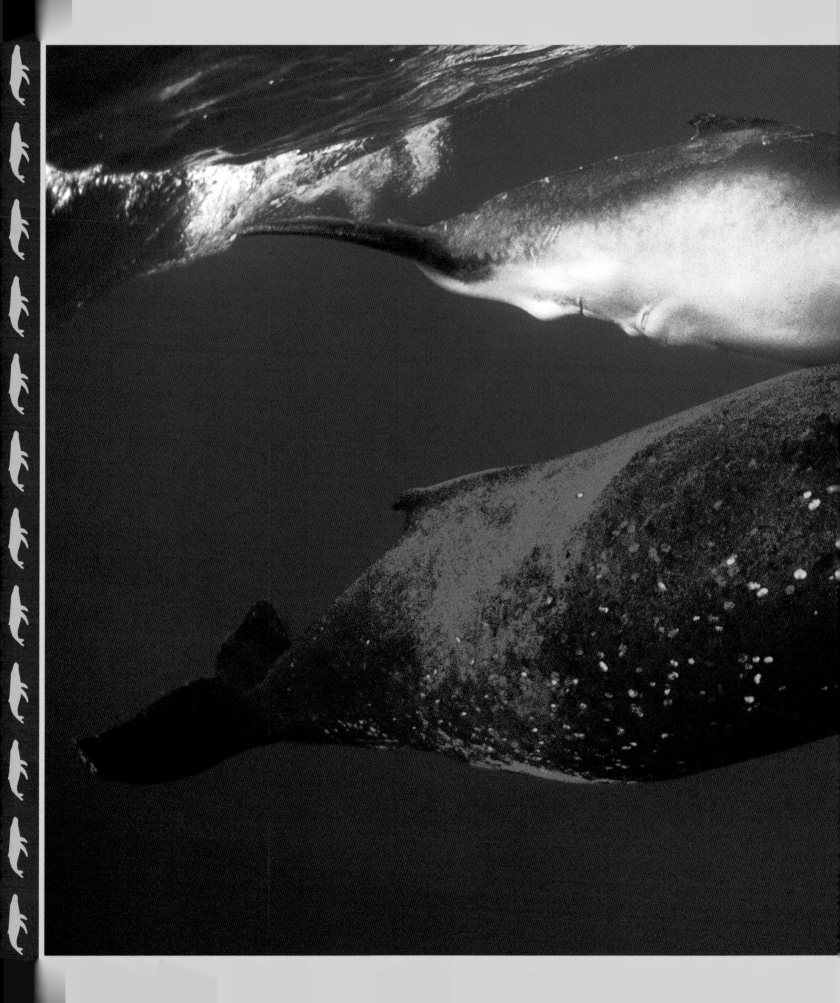

A **humpback whale** swims with her baby in the ocean.

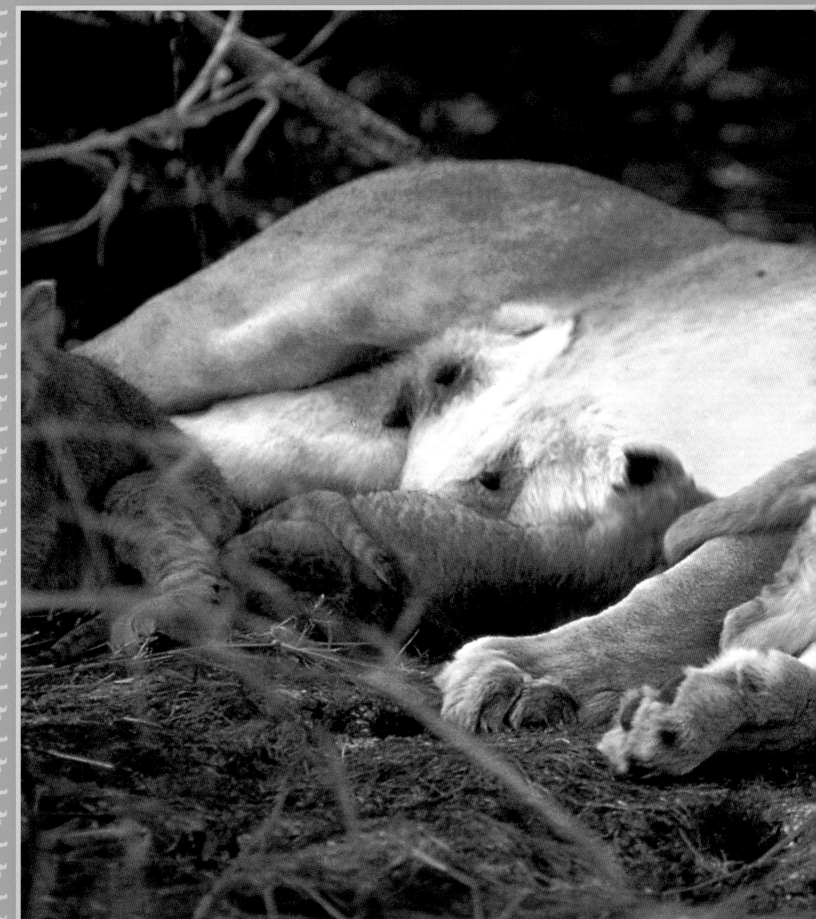

A **lioness** takes a nap with her babies.

A **hippopotamus** shows her baby how to take a bath.

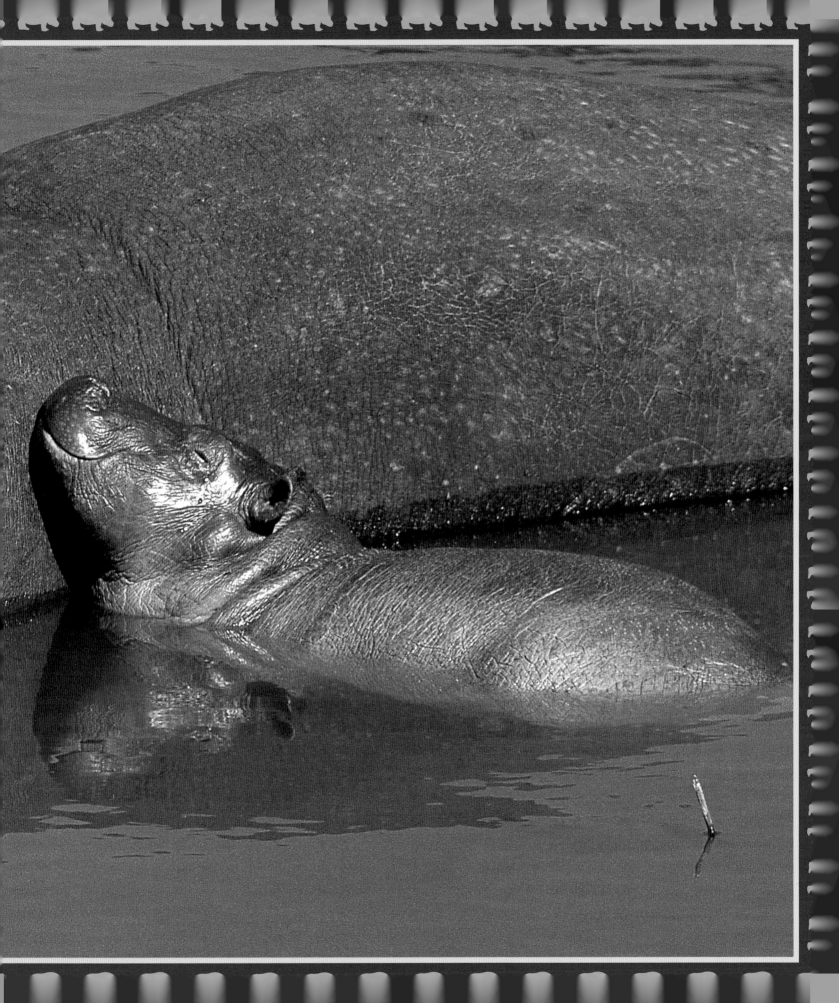

A **polar bear**
gives her baby a
cozy place to sleep.

Animals love their babies—
just like humans do.